GUSTAV KLIMT

Silver, Gold, and Precious Stones

Prestel

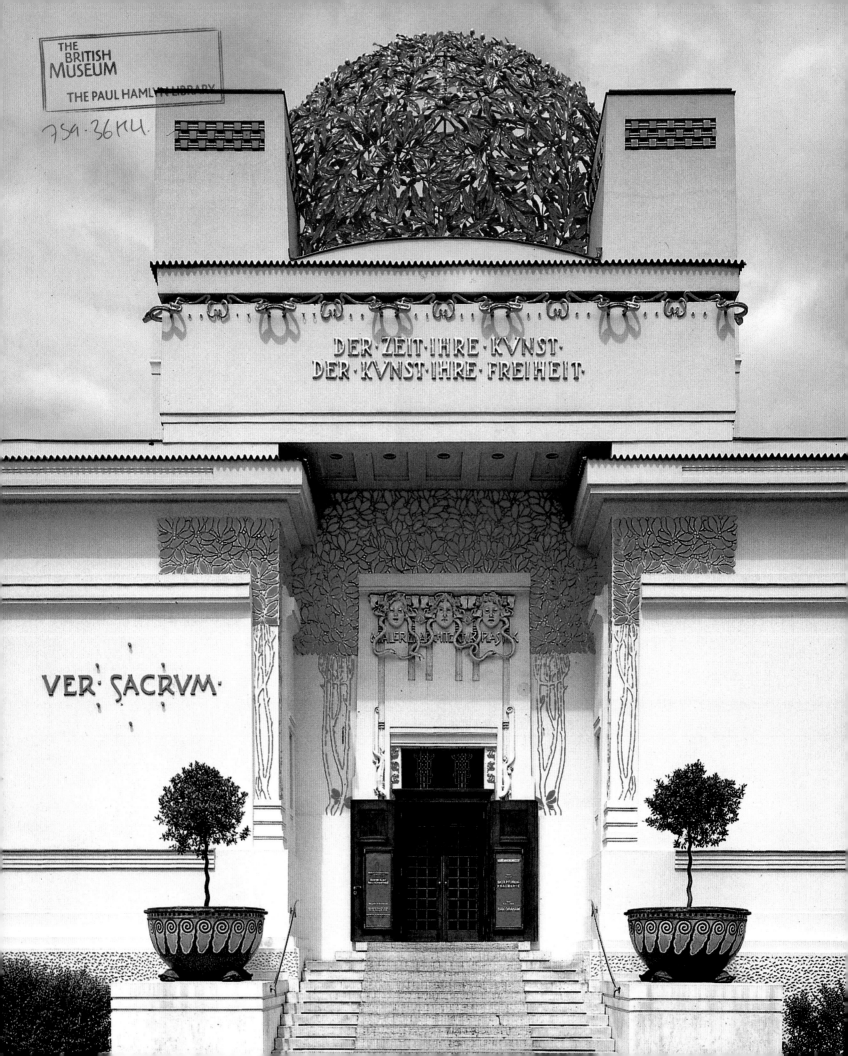

DER·ZEIT·IHRE·KVNST·
DER·KVNST·IHRE·FREIHEIT

VER·SACRVM·

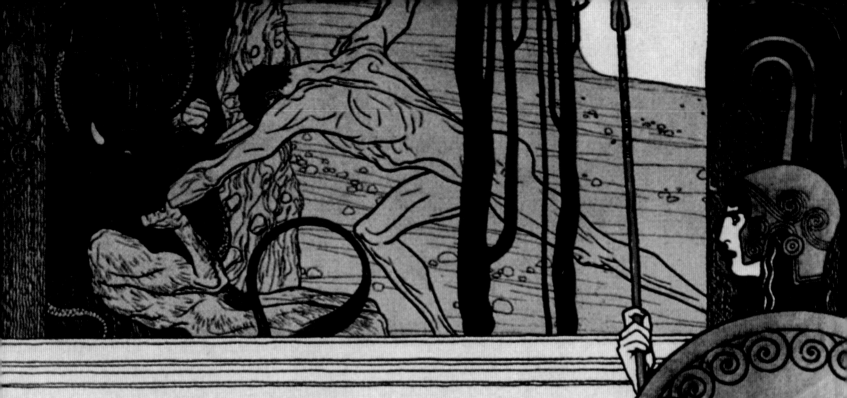

A break with tradition

A simple, clear style is what people want—in painting, architecture, and in the decorative arts.

A new age needs a new artistic style.

This is the artist Gustav Klimt's motto and also that of the many young artists living in Vienna about a hundred years ago. A call for change is spreading across Europe, and a modern style called 'Art Nouveau' is beginning to emerge. In the Austrian capital, some artists decide to form their own group, the **Vienna Secession**, and Gustav becomes this group's first president.

'Vienna Secession' is also the name given to the exhibition building designed especially for the young artists by the architect Joseph Maria Olbrich. A glistening dome of gilded laurel leaves sits on top of the building like a magnificent crown.

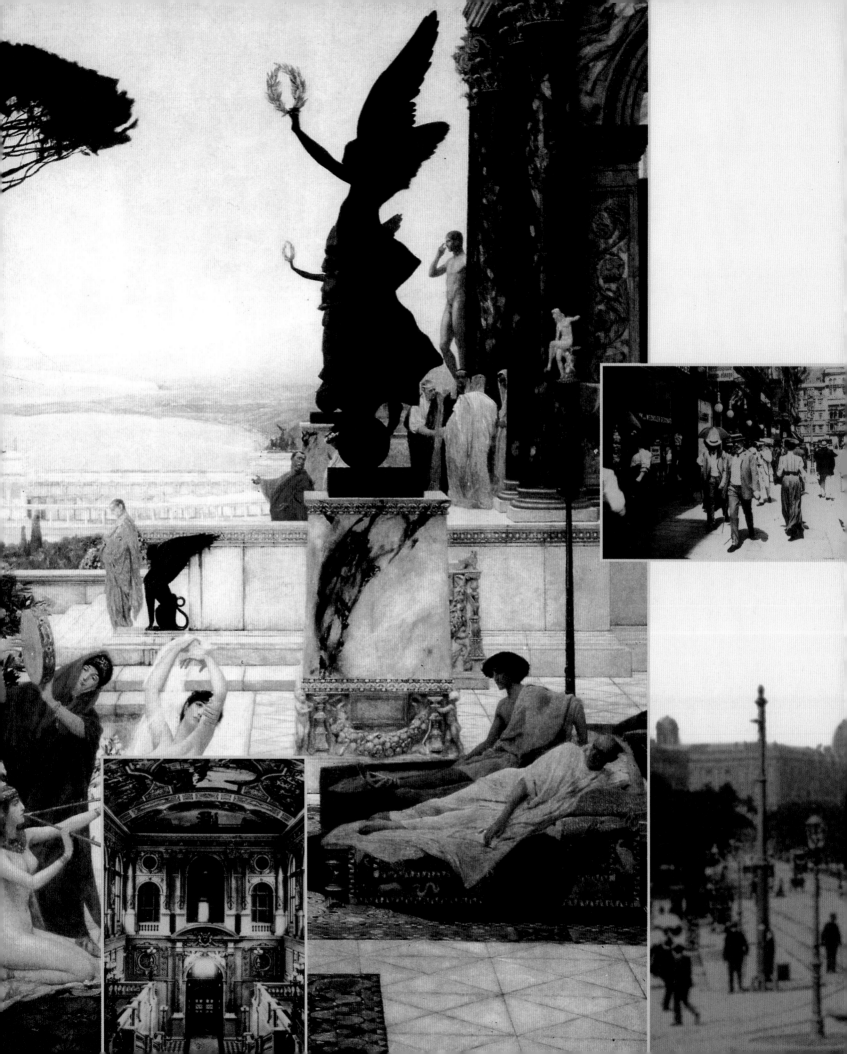

Let's take a step back in time

When Gustav Klimt decides to radically rethink his approach to art he is thirty-five years old and already a successful and highly-respected artist working on major commissions.

There is such a lot to do in Vienna! The Emperor has had a grand new road built, flanked by magnificent museums, an opera house, a new theater and elegant private houses. They look as if they were designed long ago—but really they are all brand new!

Inside these buildings the bare walls are just waiting to be decorated with paintings. In keeping with the historical style of the buildings which was so popular before 1900, the public loves to see portraits of famous figures and grand scenes from life in the olden days. This style of history painting, as it is called, has helped many an artist to fame and fortune.

Gustav also paints scenes in such a style, just like the one on the left for the Burg Theater.

But from now on, he wants to do something completely different.

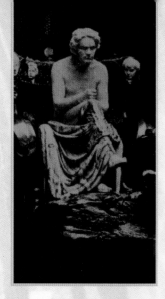

The BEETHOVEN Frieze

In the building with the glistening dome of gilded laurel leaves a German artist called Max Klinger is at the center of attention. In the main room there is his sculpture made of marble, ivory, and onyx of the famous composer Ludwig van Beethoven. Gustav decorates the room leading to the monument to Beethoven with a beautiful wall painting.

Nobody in Vienna has ever seen anything like this before!

Longing for happiness

Gustav Klimt does not paint directly on the surface of the wall. Instead, reeds are stretched onto a wooden framework which is then plastered over. Gustav paints on the plaster, leaving some parts of it untouched. This pale color is the tone he chooses for skin, for example. Gustav covers other areas with gold. Then using buttons, pieces of broken mirrors, and costume jewelry made of colored glass, he produces all sorts of fabulous patterns.

Gustav shows how very important both love and art are to all of us, basing his painting on the music of Beethoven's Ninth Symphony. The composer had, in turn, put a famous poem called 'Ode to joy' to music. Perhaps the angels in the painting are merrily singing a well-known line from it: 'Joy, fair spark of divinity, here's a kiss for all the world!' The lovers, all in gold, shown next to the choir of angels, are a symbol for happiness.

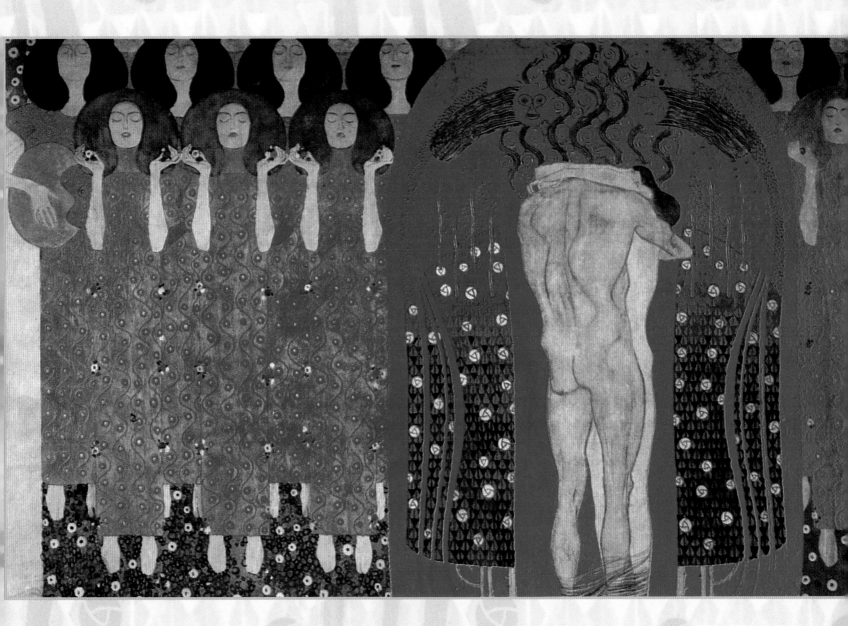

The exhibition itself is a work of art.

Keeping up with the times

Gustav's girlfriend, Emilie, is a dress designer who, together with her two sisters, runs one of the most fashionable stores in Vienna. The stunningly designed interior attracts the most elegant ladies in the city who go there to buy the latest fashions. But they have to be pretty daring too

Up until now, fashionable women have been wearing dresses like the one shown in the small photo below. They squeeze themselves into tight corsets which push the stomach in and pinch the waistline—so much so that sometimes they can't even breathe properly. That's why they always have their smelling salts close at hand.

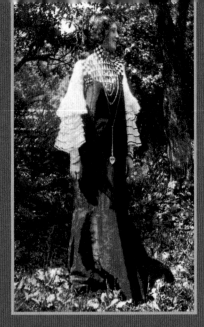

For some time now, doctors have been calling for a ban on the corset. The so-called

Dress Reform Movement

has come into being; the clothes are

simple, loose-fitting,

flowing—and comfortable!

Emilie and her sisters latch onto this new trend for their store. Gustav, who prefers to wear loose-fitting artists' smocks to tailor-made suits, has designed ten flowing dresses together with Emilie, and taken photographs of her to show off the different styles available in her store, as in the photo above.

In 1902 Gustav painted a picture of Emilie wearing a dress in the latest style. The flowing material hides the waistline and the wavy lines, spirals, circles, and squares, that are to become typical of Gustav's paintings, can be clearly seen.

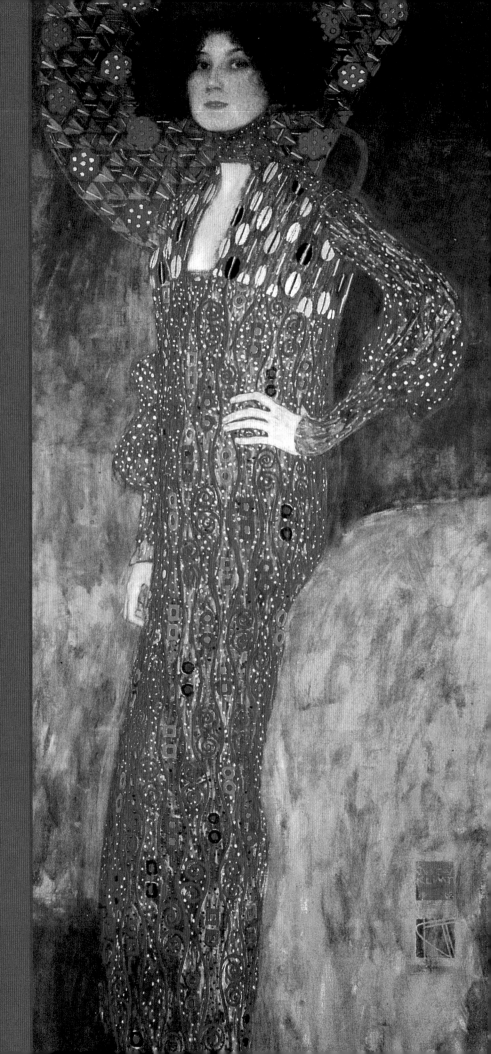

Summer days at the lake

Gustav takes photos of Emilie modeling clothes at Lake Atter in Upper Austria, where for many years the two of them spend the summer months.

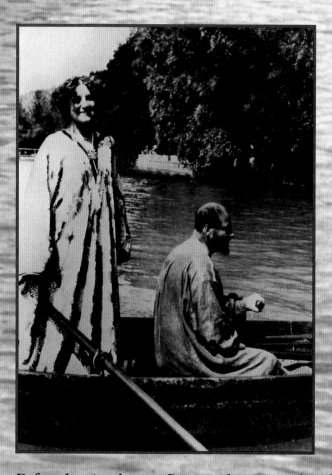

Before leaving home, Gustav always sends a large trunk of wooden picture frames and canvases on ahead to wherever he is staying. He likes working outside in the summer in the fresh air and often takes Emilie out on the lake in a rowing boat, as can be seen above.

In the middle of the lake he stops and paints landscapes such as this one. You can hardly see anything of the water glinting in the sun, but from the boat Gustav has a good view of the houses and gardens along the banks. He always has a small picture frame made of ivory in his bag of artist's materials and takes it out, holds it up, and then selects the area he wants to paint. Here you can see that he has chopped off some of the buildings and part of the roof, and none of the sky shows at all. Don't you think that the painting looks like a carpet with brightly-colored, geometrical patterns?

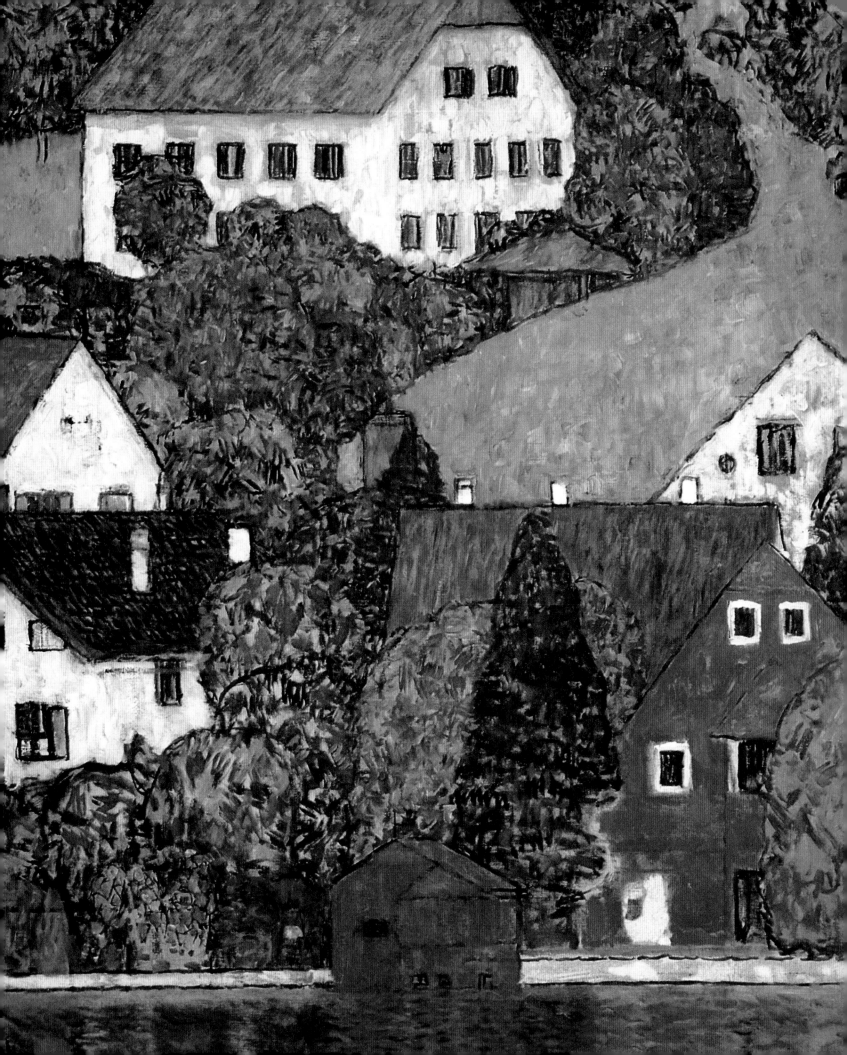

The Gold Rush

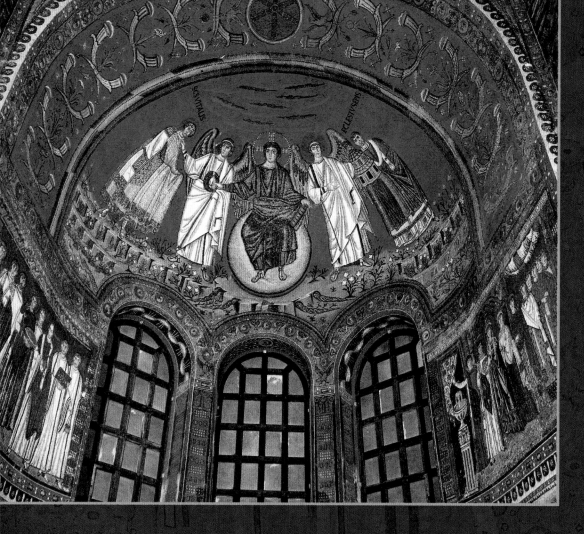

In 1903 Gustav goes to Italy twice even though he can't speak Italian and starts to feel homesick even before crossing the border! But Italy is bursting with fantastic works of art and he especially wants to go to Venice and Ravenna to see the beautiful mosaics. This one can be seen in San Vitale church in Ravenna.

The exquisite mosaics have a strong influence on Gustav and this can be seen quite clearly in the pictures he paints after returning from Italy. He uses a lot of gold, not just gold paint but even real gold—wafer-thin gold leaf. The gold in the mosaics symbolizes that this is not a scene on Earth but somewhere in heaven instead.

The couple in Gustav's famous painting The Kiss are shown in heavenly paradise as they are in love. Countless flowers surround them, and their clothes are rich in detail: the man's garments are covered in sharp-cornered rectangles while the lady's have softer, more rounded shapes and floral designs. A golden cocoon protects the lovers. Gustav decorates the picture with spirals which are a symbol of never-ending life.

Gustav Klimt is not painting a picture of any one particular couple in love. Instead, The Kiss is a symbol for complete happiness and the feeling of fulfillment.

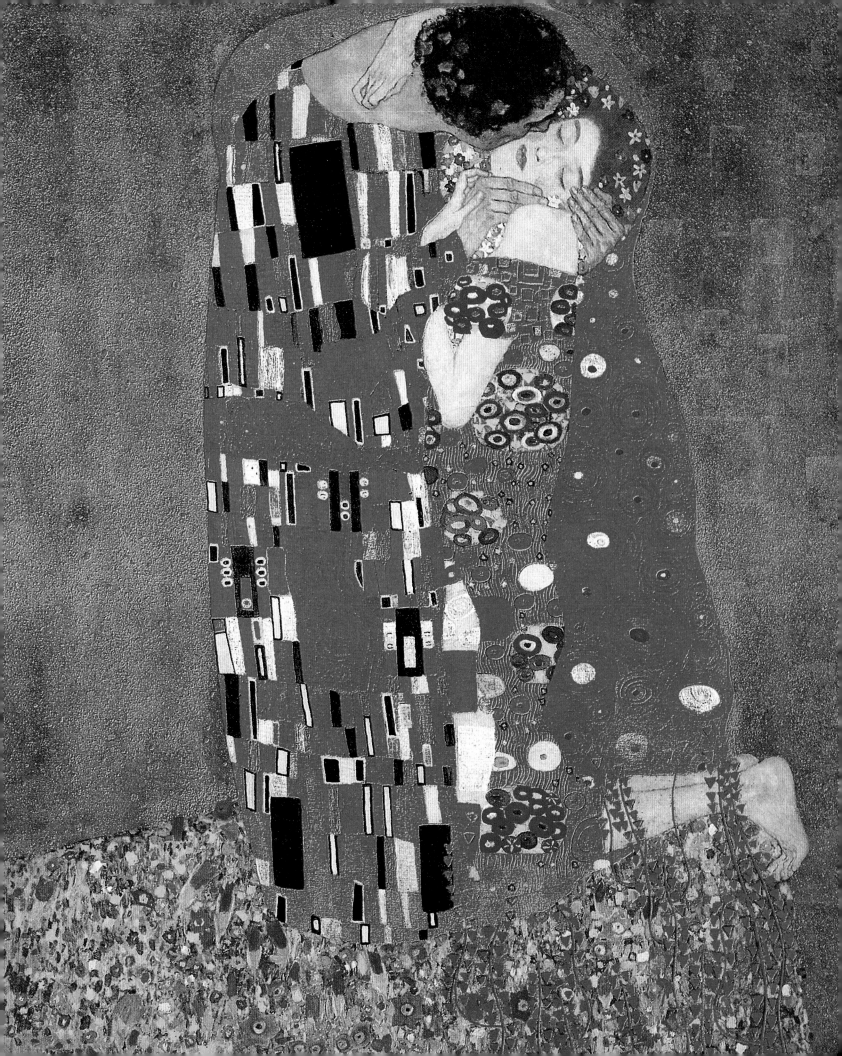

Golden portraits

Gustav Klimt also uses gold in his paintings of society ladies who ask him to paint their portrait. But gold and silver have a different meaning here than in *The Kiss*.

The precious metals and the extravagant patterns reflect the lady's wealth —and perhaps Gustav simply wants to express his admiration as well. Adele, the lady in these pictures, almost seems to be swimming in a flurry of gold.

Adele is portrayed with her hands folded in a very lady-like pose. Gustav pays special attention to capturing the wonderfully soft quality of her pale skin. Her head, shoulders, arms, and hands have been painted in a very life-like way. Quite the opposite is true of her dress which seems flat as if nobody is really wearing it. It flows in waves and is covered with geometrical shapes.

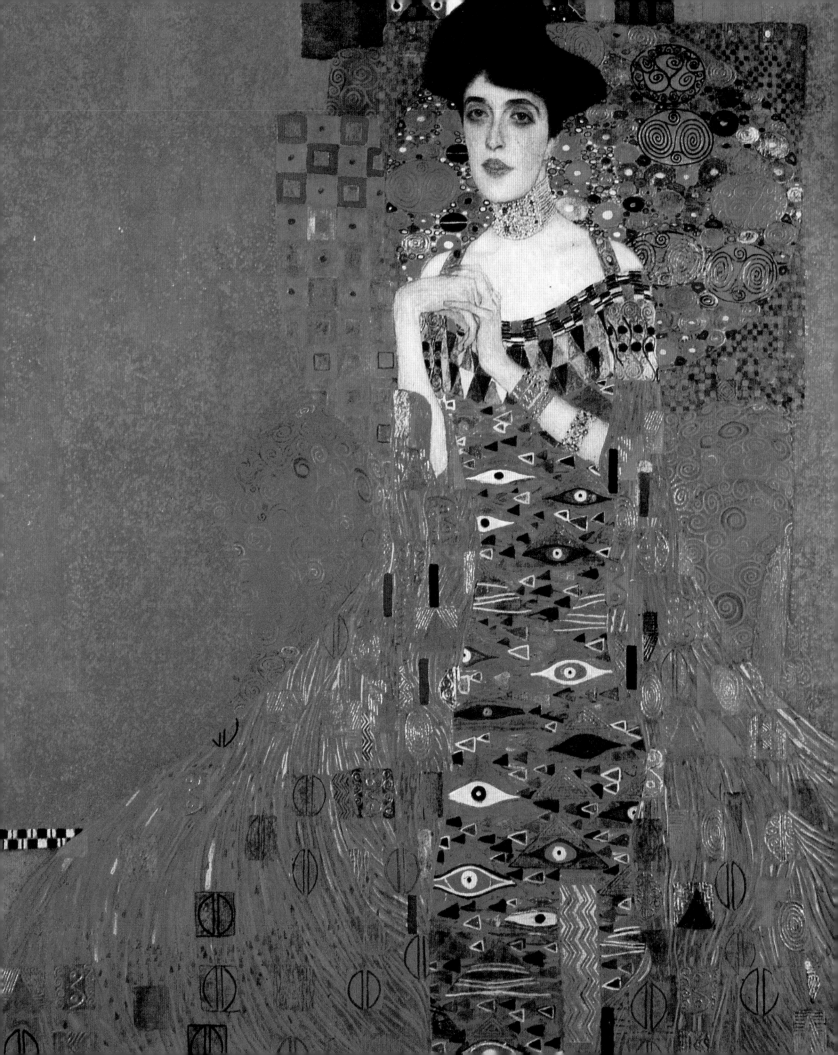

A house
as a work of art

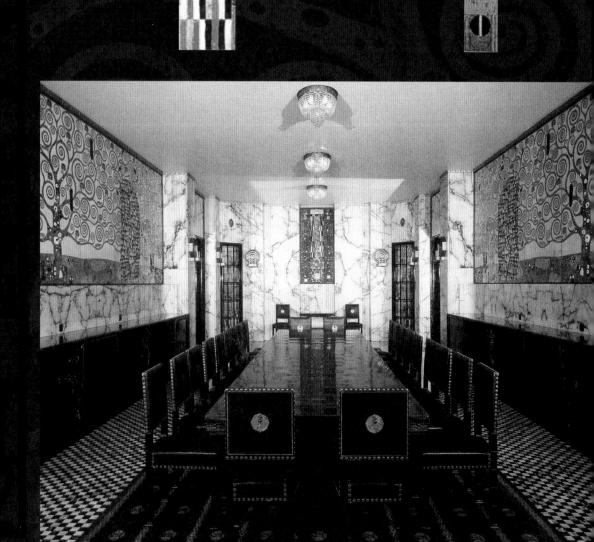

Gustav can use as much gold and as many precious stones as he likes on a special job he is asked to do in 1904. A young Belgian industrialist called Monsieur Stoclet and his wife Suzanne are having a magnificent house built for themselves in Brussels. The architect, Joseph Hoffmann, who comes from Vienna, also designed the interior of Emilie's shop. Gustav has been asked to decorate the dining room—in fact all the art work and decoration for the house are being made in what is known as the 'Viennese Workshop.' This workshop was founded by some of Gustav's friends who are painters, sculptors, and architects, and they work on everything in the workshops first before sending them off to Brussels.

A dream comes true! The artist friends transform the Stoclet's house into one gigantic work of art. From the windows and doors, the furniture throughout the house and even the bathrooms, right down to the knives and forks in the drawers—everything matches perfectly. Art influences everything here, even while eating or having a bath!

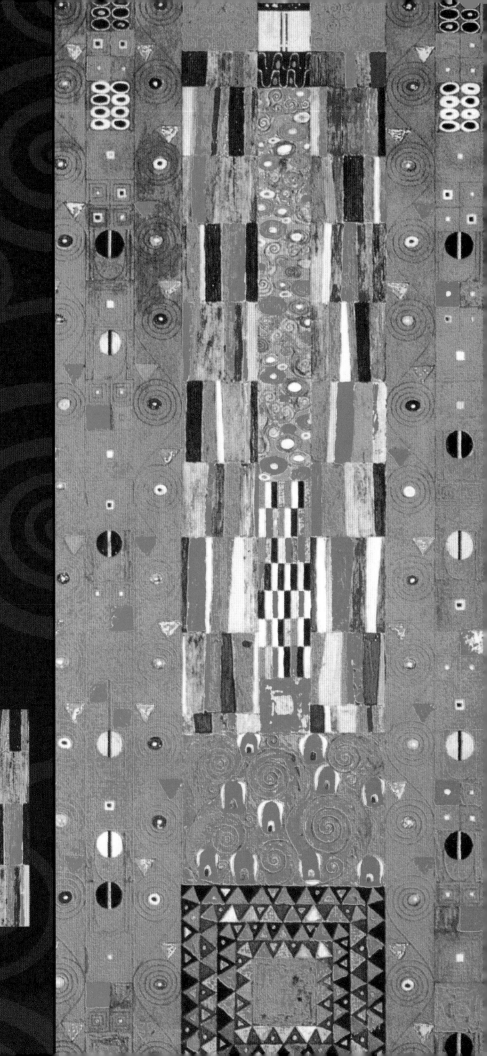

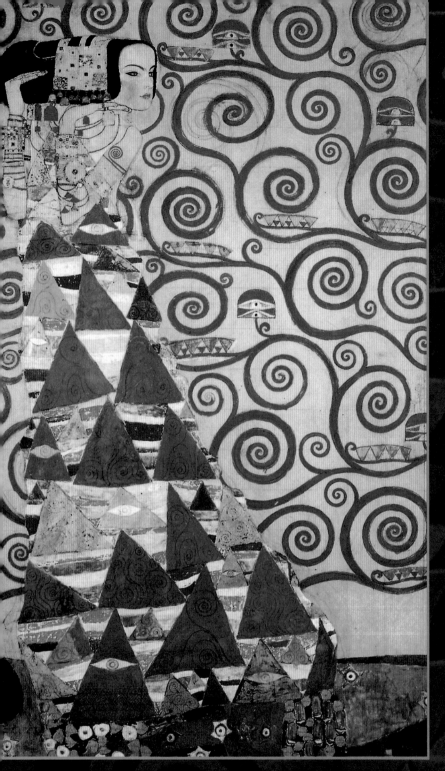

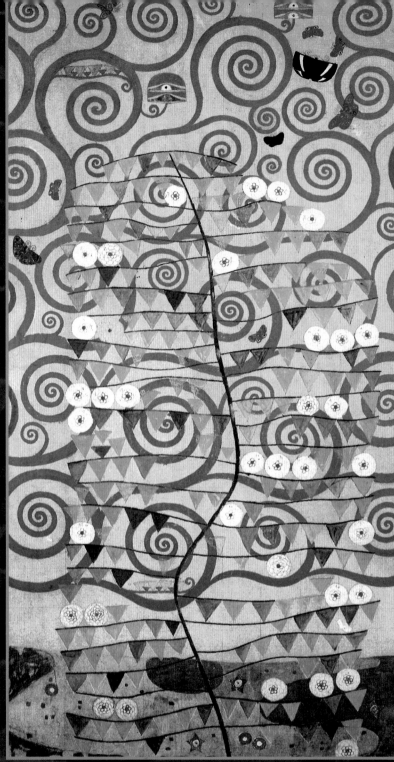

A feast for the eyes

Gustav designs an exquisite mosaic. He can still picture the wonderful church in Ravenna quite clearly. Using his designs—as shown here—the artists in the Viennese Workshop set glittering semi-precious stones and beautifully colored pieces of coral, glowing enamel and shining ceramics, sparkling gold and gleaming copper into a number of glistening white marble slabs. This is just the way Gustav wants everything to be and he keeps a very close eye on every detail.

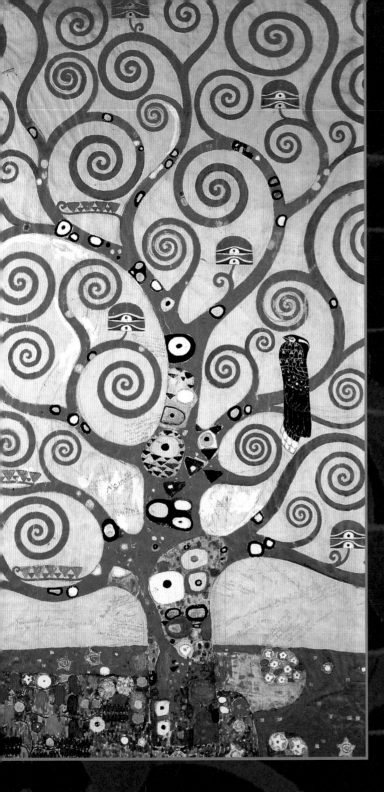
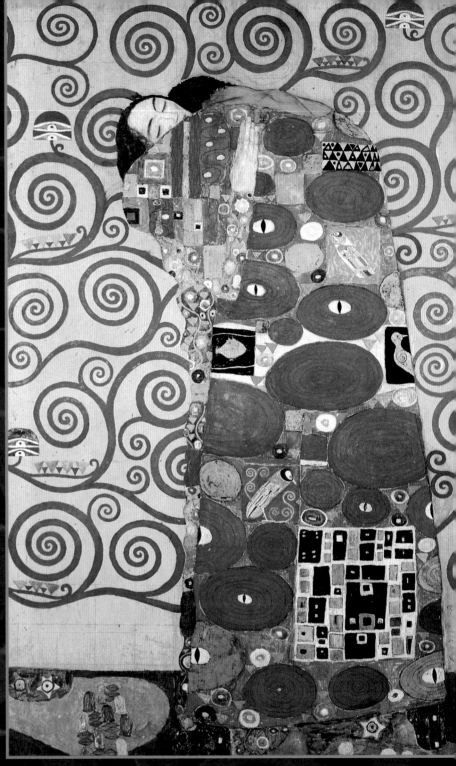

The precious materials form huge spirals. On the far left there is the figure of a lady, and on the right, a couple embracing. The robes they are wearing seem so flat that you would never guess that there is anyone inside! Green triangles and red and white circles make up a picture of flowering roses, and spirals form the branches of the spreading 'Tree of Life'. What secrets do you think the strange looking birds and the pairs of eyes on the branches would be able to tell ?

Decorative patterns, plants, and figures are barely distinguishable from one another. This frieze for the Palais Stoclet is the highlight of Gustav Klimt's 'golden' style.

There are many people in Vienna who admire Gustav Klimt's work and buy his paintings, furnish their houses from the Viennese Workshop, and wear the latest fashions—just like the lady in this picture.

She's wearing a beautiful new dress and a jacket made of an exotic fur by the Viennese Workshop, and is modeling these clothes for Gustav. He is not so keen on the plain jacket and suggests turning it inside out so that we can see the colorful pattern on the lining. That's much more to his liking!

He doesn't use gold at all any more—instead there are lots of delicate shades mixed with white. He doesn't apply the paint in the same way either. In fact he often just dabs the paint onto the canvas, and here this has made the fur around the edge of the jacket look particularly thick and fluffy.

Patterns from the Far East

The wallpaper shows some wild scenes from a tournament and Gustav has taken some figures he first saw on a vase from Korea as the basis for this pattern.

He often finds ideas for paintings from his collection of works of art from the Far East. He has some woodcuts and a red and black suit of armour from Japan, two Chinese pictures and a whole cupboard full of beautiful Japanese and Chinese garments. Emilie is wearing one of these in the small photograph on this page.

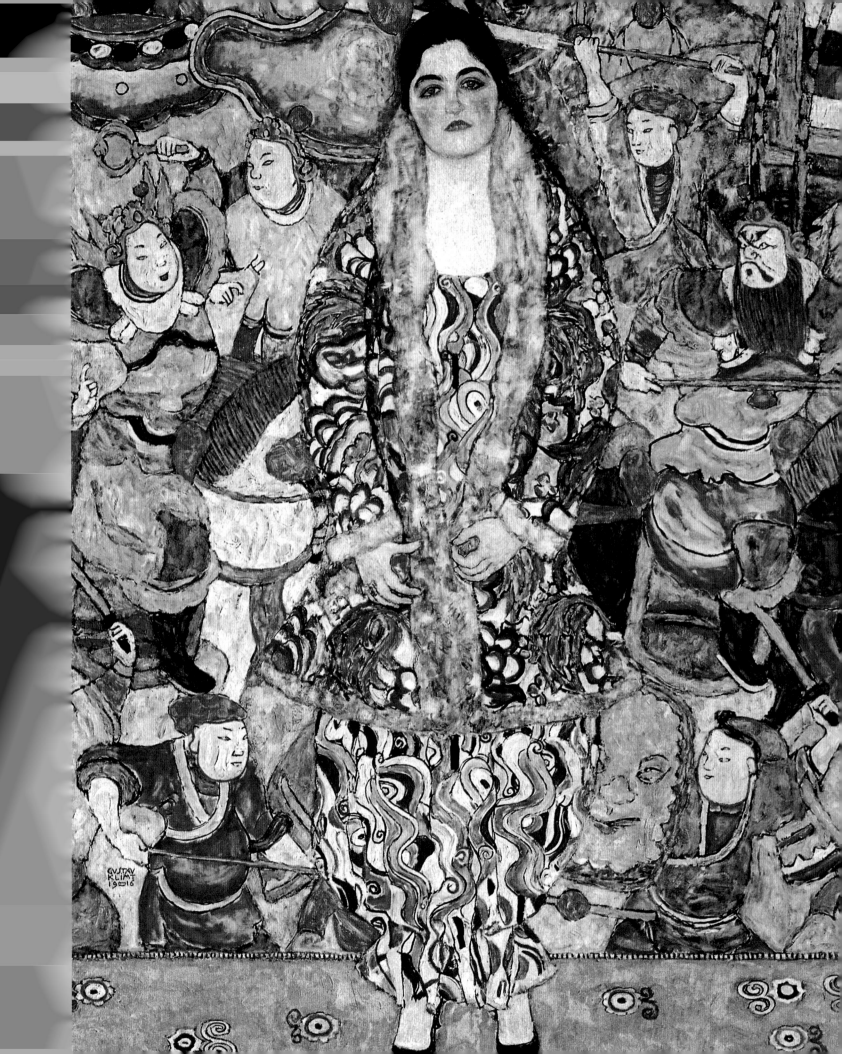

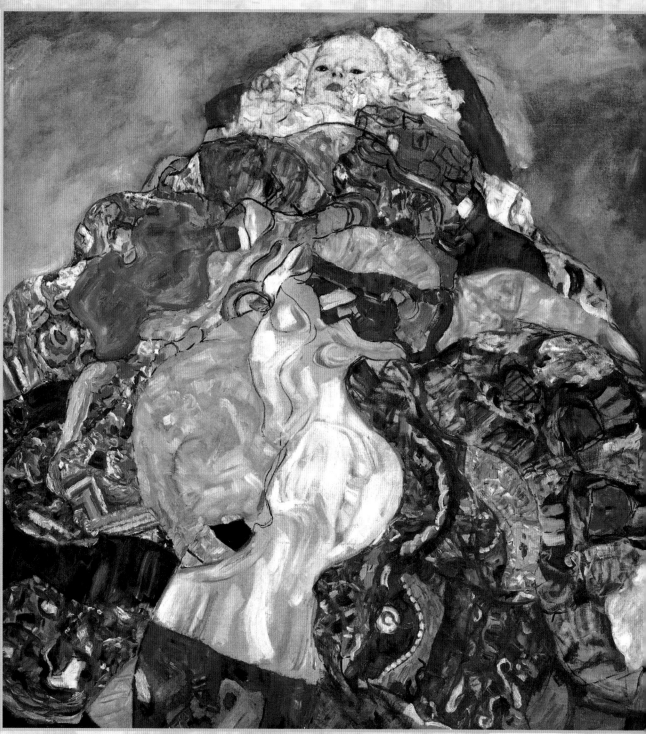

Where's the baby? It is barely noticeable! Just its little head and a tiny right hand are poking out. Gustav can really let his imagination run riot and paint a mountain of brightly colored blankets covered with decorative patterns. Unlike his earlier 'golden' paintings, the material here has folds that hide parts of the pattern and some of the colors. It seems though that Gustav never finished this painting.

This girl with the broad satin bow in her hair is looking at us with a serious but confident expression. Her portrait also shows up Gustav's new style of painting very well. The girl's curly brown hair, her glowing pink cheeks and her gleaming eyes are painted carefully and accurately, and Gustav depicts the silky material of her dress in just the same way.

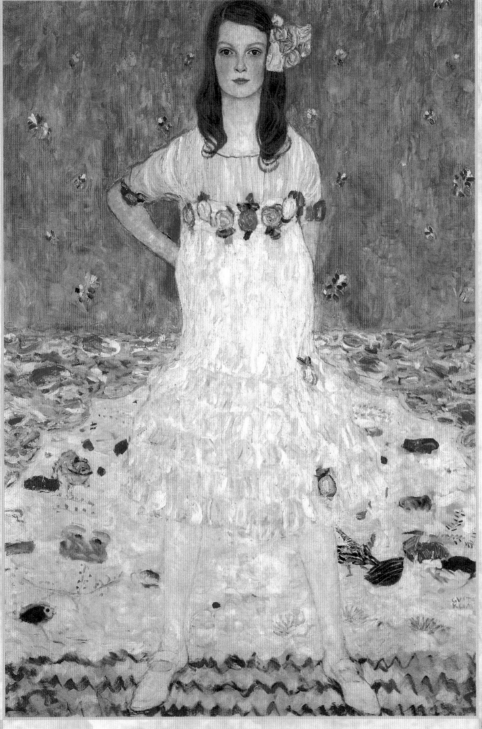

The many shades of pink used in the background perfectly match the roses on the girl's dress, and are picked up again in the pattern on the floor. The carpet is particularly funny—with lots of little animals on it. At the bottom on the left there is a fish, for example, and a cat is sitting just above it.

Gustav loves flowers and not just those on patterns for material but real ones too. For many years he worked from a little summerhouse in the garden. His last studio is also surrounded by meadows, and he has planted up a number of flowerbeds all round his house.

In Gustav's paintings there is not much difference between the flowers on the little girl's dress, the wallpaper and the carpet in her room, or the flowers outside in the garden!

Here Gustav has painted daisies and dandelions. Most of Gustav's landscapes are rectangular—picked out with his ivory picture frame. But just as important as the frame are his opera glasses. Whenever he leaves them behind before setting off for the summer months he has to have them sent on later. With the opera glasses he studies the area he wants to paint really thoroughly. He never shows any of his landscapes from a distance—from where they would normally be seen, especially in the mountainous area around Lake Atter. Gustav is not interested in wide expanses. He prefers everything to be compact and fill the canvas.

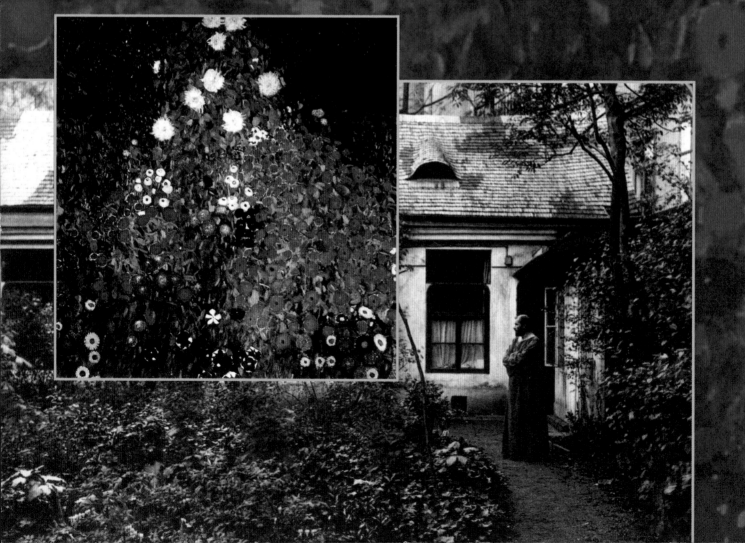

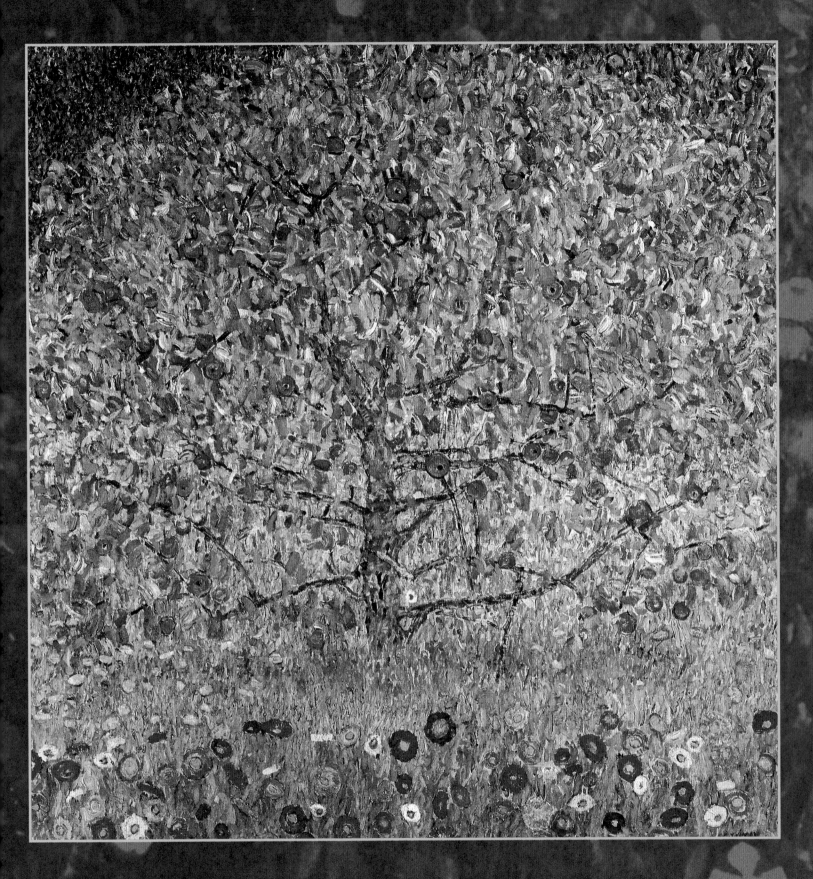

The apple tree is glistening like the surface of a mosaic.
The leaves seem to be made up of little blue, yellow, and green
fragments that surround the circular, red shape of the apples.

Everything merges
into a flurry of color!

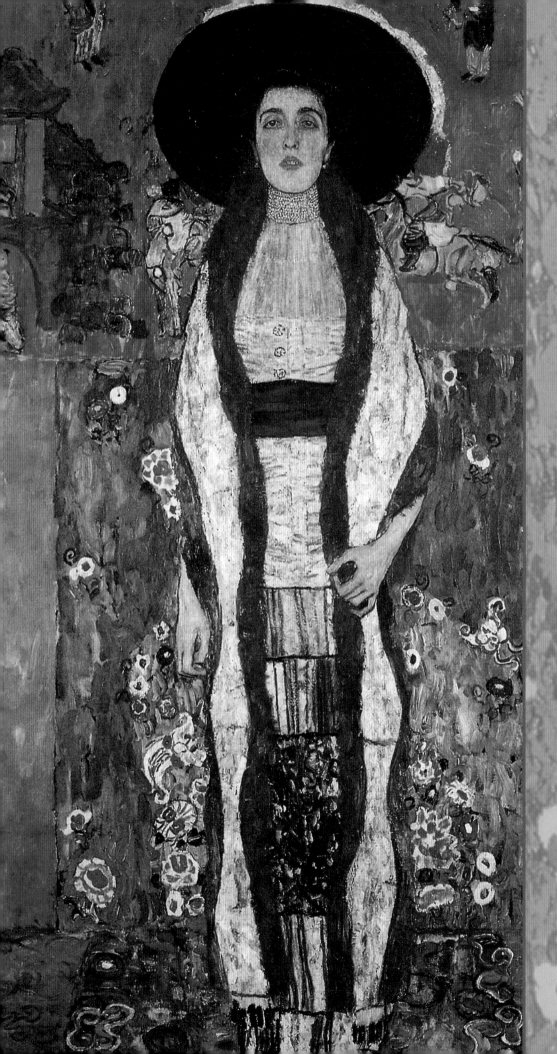

When

is a

flower

not a

flower ?

In this picture of Adele can you spot the things that make it different from his portraits in the 'golden' style?

Take a look at the shades of color he uses ranging from pink, red, green, and violet, to gray and white. And Adele is now sporting a black hat.

In both portraits Gustav is playing with contrasts: the carefully painted face and hands are set against the flat robes and background. There are powerful, geometrical shapes and dynamic, wavy lines as well as areas painted in one color and others which are multicolored. The foreground merges with the background and all the little pieces of mosaic form one magnificent picture.

And Gustav paints in just the same way when he is working on his garden pictures and his landscapes too.

Doesn't this wonderful picture of a sunflower with its luxurient robe of leaves remind you of an elegant lady dressed up to go out?

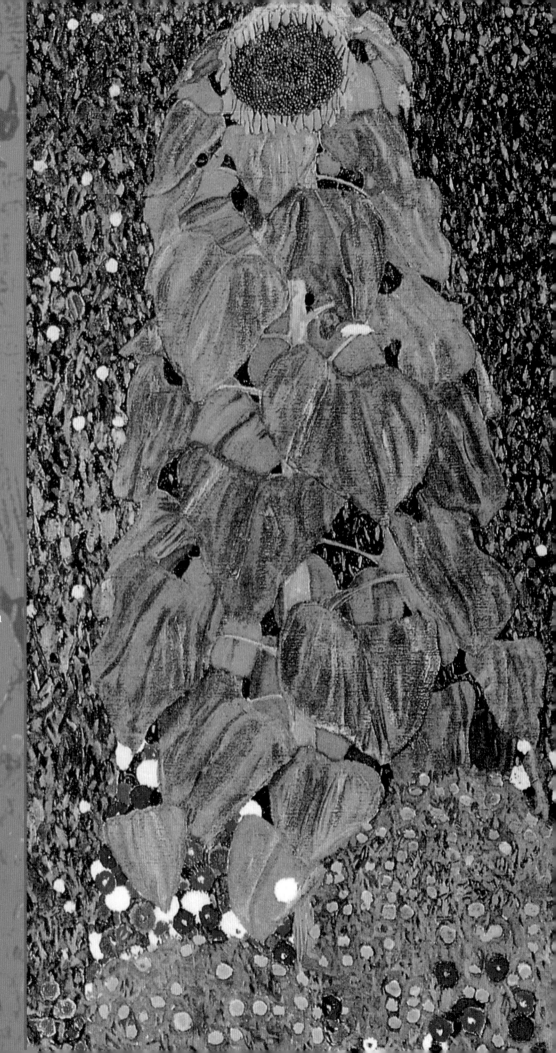

Gustav Klimt's life story

Gustav Klimt was born on July 14, 1862 in a suburb of Vienna. His father was a gold engraver—a skilled craftsman who copied patterns and drawings onto gold.

Gustav had one older and three younger sisters as well as two brothers. One of his brothers, Ernst, who was also an artist, married Emilie's sister, Hermine. The other brother, Georg, sculpted in metal. He cast the bronze door for the 'Vienna Secession' building.

Gustav studied at the Academy of Decorative Arts in Vienna for seven years, before setting up his first studio. He received a number of important commissions from the Imperial Court to paint pictures for theaters and other public buildings. When Gustav decided to put history painting behind him and became president of the Vienna Secession, neither the Emperor nor the aristocracy showed any more interest in his work. However, young artists and the more liberal classes in Vienna admired his work greatly.

Gustav only lived to be fifty-six years old. He died on February 6, 1918. He left behind some 220 paintings and thousands of drawings.